A Japanese Garden Journey

A JAPANESE GARDEN JOURNEY

Through Ancient Stones and Dragon Bones

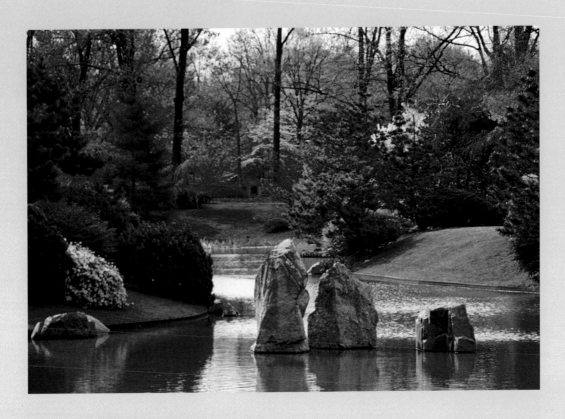

TEXT AND PHOTOGRAPHY BY JUDITH D. KLINGSICK

Stemmer House

Publishers

日本庭園紀行

Inquiries should be directed to
Stemmer House Publishers, Inc.
2627 Caves Road
Owings Mills, Maryland 21117

A Barbara Holdridge book

Printed and bound in Belgium

Dedication
For my husband Rich, who walked the garden journey with me

Acknowledgments
Special thanks to Kristen Michele McCrady and her students in Japan for their translation and research assistance, to Shiro Katagiri at
Kiku Enterprises in Minneapolis for his knowledge and expertise in the history, language and culture of Japan, and to Tamao Goda at the
Journal of Japanese Gardening for the *kanji* transcription of the book's title.

Front cover photograph by Judith D. Klingsick of the Japanese House and Garden, Fairmount Park, Philadelphia, Pennsylvania, reproduced
by permission of the Fairmount Park Commission of the City of Philadelphia

Back cover (top) photograph by Judith D. Klingsick of eight-plank bridge with irises, reproduced by permission of *Seiwa-en*, Missouri
Botanical Garden, St. Louis, Missouri
Back cover (bottom) photograph by Judith D. Klingsick of the author in a teahouse, reproduced by permission of the Minnesota Landscape
Arboretum, University of Minnesota, Chanhassen, Minnesota

Colophon
Designed by Barbara Holdridge and Hellen L. Hom
Composed in Capelli text with Fisherman display
Color separations by Jen Mar Graphics, Inc., West Paterson, New Jersey
Printed on 90 lb. acid-free matte paper and bound by Proost International Book Productions, Turnhout, Belgium

Library of Congress Cataloging-in-Publication Data
Klingsick, Judith D., 1948-
 A Japanese garden journey : through ancient stones and dragon
bones / by Judith D. Klingsick.
 p. cm.
 "A Barbara Holdridge book"–T.p. verso.
 Includes bibliographical references (p.)
 ISBN 0–88045–146–7 (hd : alk. paper). – ISBN 0–88045–147–5 (paper
: alk. paper)
 1. Gardens, Japanese. 2. Gardens, Japanese Pictorial works.
I. Title
SB458.K625 1999
712'.0952—dc21

 99–13018
 CIP

Introduction

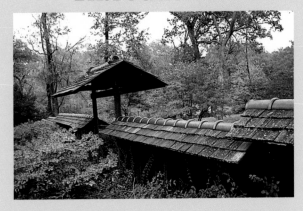

*T*his journey that wanders past ancient stones and dragon bones will lead you through strolling gardens, dry gardens, teahouse gardens and courtyard gardens; for there is a variety of styles in traditional Japanese garden design. While the styles vary in size and features, the basic principles for achieving a sense of serenity, harmony and balance remain consistent from garden to garden.

A strolling garden may be designed as a hill-and-pond or mountain-water garden. Whether one acre or fifteen, it features a winding path that reveals many scenes of hills, streams, ponds and waterfalls. On your walk through a strolling garden, you may encounter a structure such as a teahouse or viewing pavilion and ornaments such as lanterns, water basins and stone towers.

A dry garden occupies a smaller space (often no bigger than a tennis court) to suggest a natural landscape through the use of stones, raked gravel and maybe a few shrub or tree plantings. Most often associated with Zen temples, dry gardens invite you to engage in quiet contemplation and meditation.

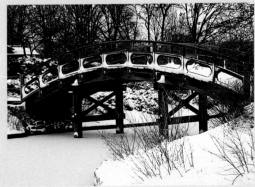

A tea garden, as the name suggests, surrounds a teahouse. Its primary feature is a stepping-stone path which invites a serene and intimate encounter with nature and sets a contemplative tone before your participation in the tea ceremony. Lanterns and water basins are common elements in a tea garden.

A courtyard garden may incorporate features from other styles, but its most distinguishing characteristic is its small size, perhaps no more than 100 square feet. It is often designed so that you can view it from a veranda or an indoor room.

Whatever its style, every Japanese garden serves as a mirror of nature. Perhaps the most vivid reflection you will see in that mirror is a "tension of opposites": delicate versus dramatic, changeless versus changing and wild versus controlled. Like the cosmic forces of In and Yō (Yin and Yang in Chinese philosophy), the opposites are never in conflict. Rather they complement each other in order to bring about balance and harmony in life as well as in the garden.

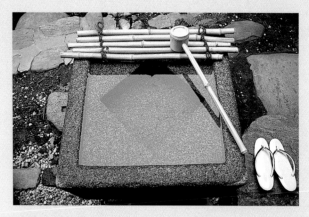

On your garden journey you may see a slender bamboo dipper laid gently across a hard-edged, steel-gray water basin. You may admire the fragile pink blossom of a camellia near the path, while at the same time hearing the pounding splash of a waterfall just around the bend. You may notice the softly sculpted ribs of raked sand as they curl around a massive, jagged rock. The delicate contrasted with the dramatic; many such encounters await you.

Change and changelessness move through the garden on a variety of timelines: aeon to aeon, season to season, day to day, morning to afternoon, moment to moment. Rocks and evergreens bring a strong sense of permanence, constancy and ancient presence to the garden, but they are contrasted with many elements that demonstrate the garden's changing nature—sunlight and shadows that momentarily play across a path, a morning dew that makes stepping stones glisten for a few hours, springtime cherry blossoms that last only a few days (and for the Samurai were an unhappy reminder of their own fleeting mortality), the golds and reds of fall that bring a brilliance of color to the garden for a few weeks. In the garden, a balance is struck between eternity and evanescence.

The wild versus controlled contrast is often translated to be a tension between nature and the human touch. The airy, windswept pine tree has obviously been pruned and trained by the gardener's hand; but when you see it, your thoughts turn to a craggy cliff by the sea, not to garden maintenance. Likewise, in the wild it is natural to find a cluster of river birches growing next to a stream; but in the garden, it is the designer who planted them there, and who situated their beautifully textured trunks to frame the view of a hilltop lantern just up ahead. Through the human touch of designer and gardener, the wild and natural beauty of the garden is idealized and revealed.

All of these contrasts achieve a harmonious collaboration in the garden, inspiring you with feelings of serenity, peace, a closeness to nature and a renewed awareness of time.

As you take your Japanese garden journey through this book, you may encounter one more tension of opposites: the read-about versus the real. May your journey begin here with the turning of pages and continue with steps along a garden path . . . and may you find that this book and the garden have indeed been a harmonious collaboration.

J.D.K.

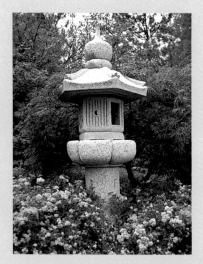

Vowel sounds in the Japanese language: "a" (ah), "e" (bet), "i" (machine), "o" (boat), "u" (moon)

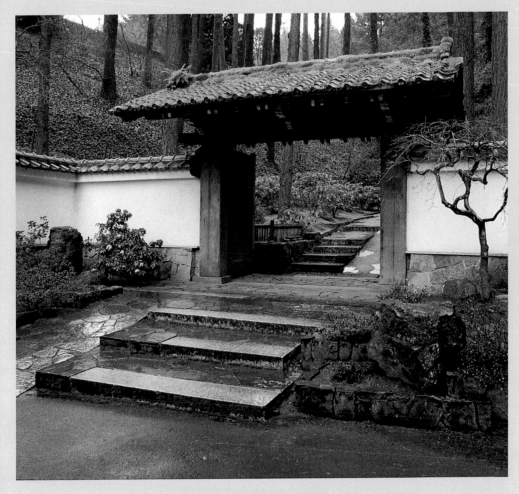

When you walk through the gate of a Japanese garden, you begin a journey of the imagination. In fact, a Japanese garden is often called "a garden of the mind."

A Japanese garden invites you to discover all of its secrets and surprises. Use your senses to better understand the details—things like water, rocks, plants, lanterns, bridges and pathways. Use your creativity to appreciate the garden as a whole—its beauty, its respect for nature, and its ability to express a sense of peace and harmony.

The garden is waiting for you and your imagination. The gate is open. Come in. Come in.

Japanese garden, what's your surprise?

Ancient stones

And dragon bones—

Come see with the mind as well as the eyes!

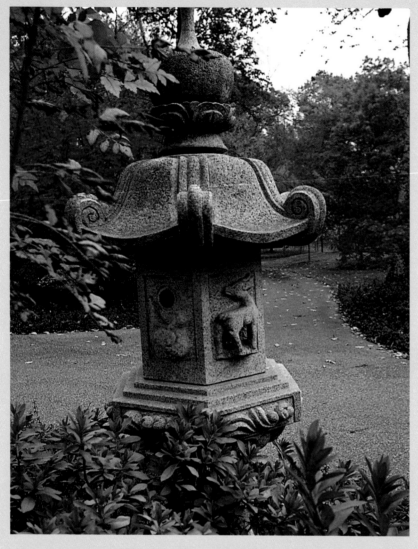

Regal in size and appearance, the *Kasuga* lantern often stands at a prominent location within a garden—near a gate or at a major intersection of pathways. Anywhere from five to ten feet tall, it displays a pagoda-style *kasa* or "hat" and a panel featuring the image of a deer.

Some lantern styles indicate the name of the temple or shrine where they first appeared; thus, the *Kasuga* lantern is named after the ancient Kasuga shrine located in Nara, Japan. Near the site of the shrine is a famous deer park where tame deer wander about freely among visitors.

In ancient legends, deer served as "messengers of the gods," carrying news from paradise to earth.

Kasuga lamp, how bright your blaze!

Even dazing

Heaven's courier,

Lighting gates and garden ways.

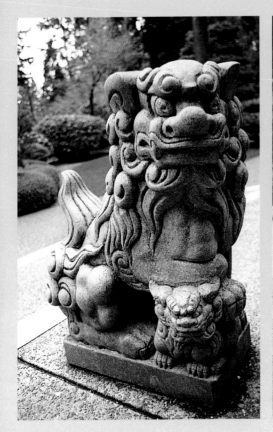 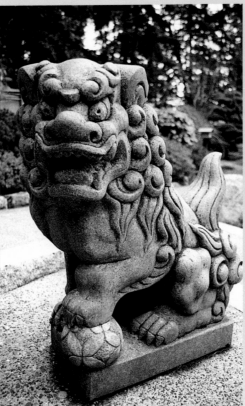

Guarding lions (*koma inu do*) traditionally stand near the entrance gate of a Japanese garden or temple. The female lion uses her strength and power to protect a young cub with her paw. The male lion holds a sphere or orb, a symbol of power, under his.

The origin of the lions lies in Chinese mythology. Their presence at the gate reminds us of China's influence on some of the earliest gardens in Japan (700 A.D.).

The lions watch over and protect garden visitors— that's you!

Fierce-eyed lions, long you wait!

Brave protectors

Holding fast to cub and kingdom,

Guardians at the garden gate.

Ancient legends suggest that huge rocks heaving out of the ground are dragon bones. In fact, rocks throughout the history of Japan have been called "the bones of the earth." They are the framework or skeleton that holds the world together.

Whether they are pebbles for a river bed or boulders for a mountainscape, rocks are the most important element of a Japanese garden.

Garden designers select rocks first, before plants. They determine the rock's best "face" by looking at its veins, colors and fissures. They plant rocks into the ground, making it seem as if a rock has been living in that place forever. The more moss and lichen growing on a rock, the better, because they add age and permanence to its character.

Over the ages, stones have silently witnessed the birth of dinosaurs, the battles of Samurai, the building of skyscrapers, the launching of satellites ... and maybe even the magic of dragons.

Ancient stones, what have you seen?

History passing

Peaks and pebbles,

Gaze eternal and serene.

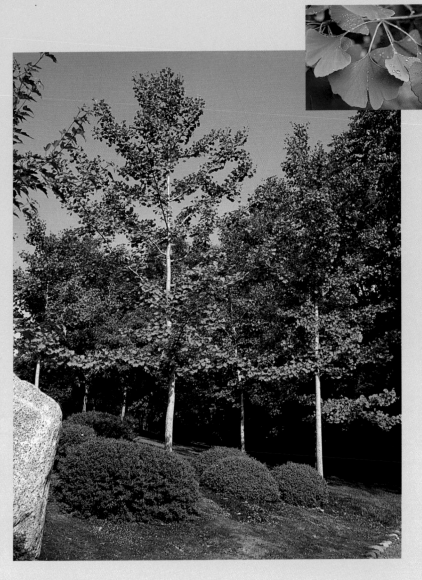

Would you believe that dinosaur food still grows on earth? As the longest surviving tree species, the ginkgo tree is old enough to have been food for dinosaurs. Around 180 million years ago, it grew in the wild over the area known today as China. Buddhist monks rescued it from extinction 2,000 years ago by planting it in their temple gardens.

Ginkgo trees were probably brought to Japan about the same time Buddhism arrived, around 600 A.D. Since then, they have been cultivated extensively in Japanese gardens. They are admired for the beauty of their leaves, fan-shaped and turning a brilliant yellow in fall.

Ginkgo trees grow slowly, but may reach a final height of more than 100 feet. Because of their hardiness and tolerance of air pollution, they are often planted along city streets today.

Ginkgo trees, were you their feast?

Fan-like leaves

Seasoned yellow,

Picnic for Jurassic beasts.

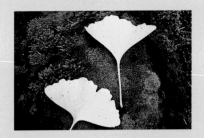

If you were to visit Kyoto, the ancient capital of Japan, you would see whole gardens where moss is the only plant used.

Moss grows vigorously in habitats where other plants find it difficult to survive. It thrives in damp, shady places, creeping over tree roots and branches, rocks and even lanterns, fences and gates. A tough plant, moss can withstand severe cold and heat by going dormant or "sleeping" until growing conditions improve.

With more than 14,000 species of moss identified, its various hues and tints of green seem endless. Its velvety texture softens the rugged angles of rocks and gives them an ancient, everlasting look. After a rain shower, moss glistens with a deep green sheen.

Green, green moss, where do you grow?

Damp and shady woodland floor,

Over trees, over stones,

Velvet sea that ebbs and flows.

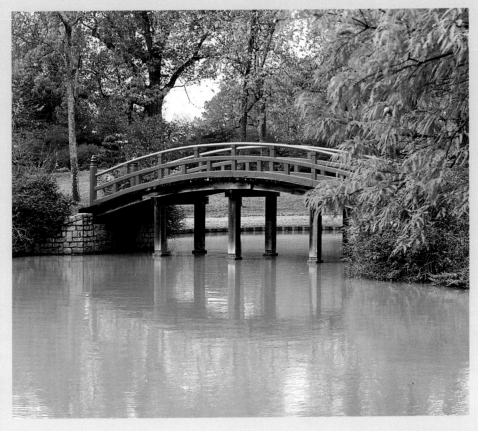

Can you guess how the drum bridge got its name? Follow the circle of the bridge and its reflection in the water. It makes the shape of a drumhead.

Using shiny red paint was an idea that first came from China. In fact, Chinese gardens often feature brightly painted bridges and pagodas.

Some Japanese gardens in North America have red-painted bridges, but many others have garden structures made out of natural, unpainted materials. They let autumn leaves and spring blossoms bring bright colors into the garden.

When you see a drum bridge (*taikobashi*), no matter what its color, think of garden rhythms. You will see them in shapes, shadows, reflections and, especially, seasons.

Bright red drum bridge, what's your beat?

Footsteps tapping,

Image dancing with the water,

Garden rhythms all repeat.

13

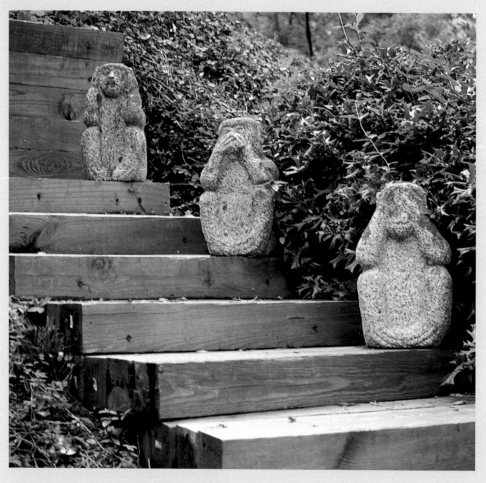

These three monkeys perform a comic pantomime along the stairway, hoping you will laugh at their funny interpretation of this old saying: Hear no evil, speak no evil, see no evil.

Always be on the lookout for a garden's playful sense of humor. In one garden, you may see a rock in a pond and think it's a crocodile floating, with its eyes just skimming the water. In another, you may follow a stepping-stone path laid out in the darting, to-and-fro pattern of a shore bird's tracks, and you end up looking just like that bird bobbing across the beach. And in another, a long chain of rocks, their heights undulating across the water, will catch your eye—perhaps a dragon is master of the pond!

Monkey trio, what is true?

Hear no, speak no, see no evil—

Ageless wisdom from the past.

Good advice for people, too.

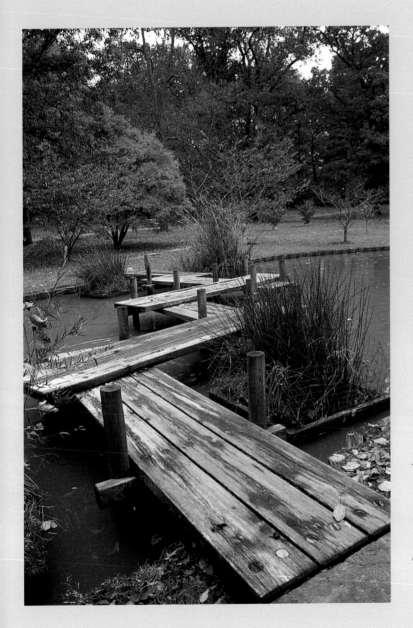

*H*ave you looked behind you lately?

Japanese legends say that evil spirits can travel only in a straight line. Therefore, bridges and pathways often use zigzags in their designs. While you can easily shift directions, the evil spirits that may be following you can't twist or turn. They either fall into the water or veer off the path, no longer able to bother you. Whew!

In addition to offering protection from evil spirits, each turn in the eight- plank bridge (*yatsuhashi*) gives you a moment to linger and enjoy a different view of the garden.

Zigzag bridge, are you a threat?

Garden friends safely cross.

If foolish spirits try to follow—

They fall in and get all wet!

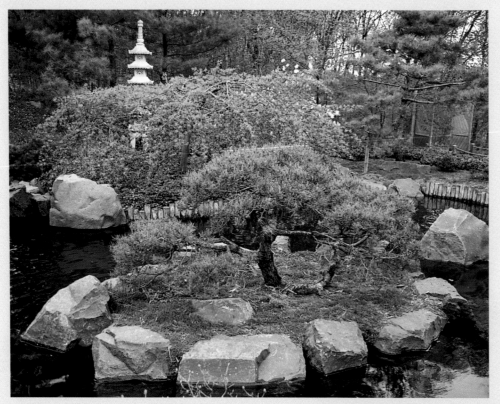

*C*an you see it? The island is in the shape of a tortoise, with the largest rocks forming its head (right) and tail. Even in a "dry garden" made of rocks and sand, you may see a tortoise island (*kameshima*) floating in a sea of gravel. The tortoise always swims toward the west, where the mystical islands of paradise are said to be found.

In Japan, the tortoise is a symbol of a long and happy life. Japanese legends say that the tortoise lives to be 10,000 years old. Pine trees, another symbol of long life, often grow on the "back" of the tortoise.

Old, old tortoise, where can you be?

Ring of rock,

Mound of earth forever green,

Island floating in the sea.

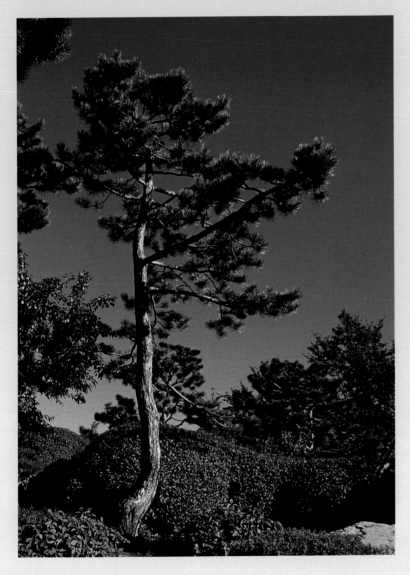

*T*he pine tree stands at the top of a metaphorical ranking system used to rate good things in the Japanese culture. *Shō, chiku, bai*: pine, bamboo, plum. The plum tree is good; the bamboo is very good; but the pine tree is best, the most excellent!

The pine tree stays green all year long and is called the "first friend of winter," its stability and permanence providing a strong contrast to the seasonal changes in nature. It lives a long time (hundreds of years) and grows even in poor soil and harsh weather conditions.

Seeing one windswept pine tree along a garden path can transport you to the rugged coastline of Japan, where it is a common sight to see a twisted, gnarled tree leaning precariously over the rocky cliffs above the shore. In many Japanese gardens, young pines are carefully pruned and shaped to resemble old, weathered trees.

Pine trees fill the garden with beauty and with memories.

Windswept pine, how old are you?

Twisted trunk,

Gnarled branches,

Centuries since you were new.

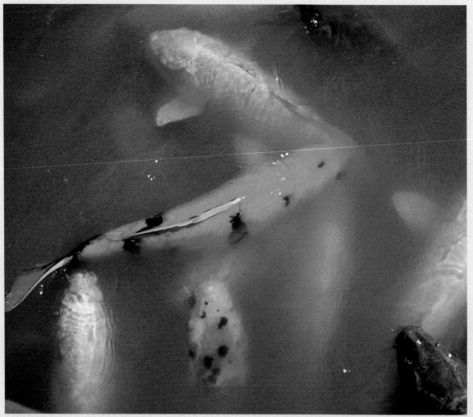

*K*oi, the colorful fish of Japan, are related to the homely carp that live in North American rivers and lakes. Their formal name, *Nishikigoi*, means "living jewels."

Feeling the vibrations in the water from your footsteps on the bridge, these *koi* have come to the surface hoping you will feed them. They can learn to come when "called" and to feed out of your hand. With excellent care, *koi* can live more than fifty years, weigh up to thirty pounds and grow to three feet long.

Bred for their colors and patterns, some champion *koi* are worth more than $100,000! You can buy common *koi* in local pet stores for as little as $10.

Koi of beauty, what's your price?

Colors shimmer.

Patterns spatter.

Watery jewels flash fire and ice.

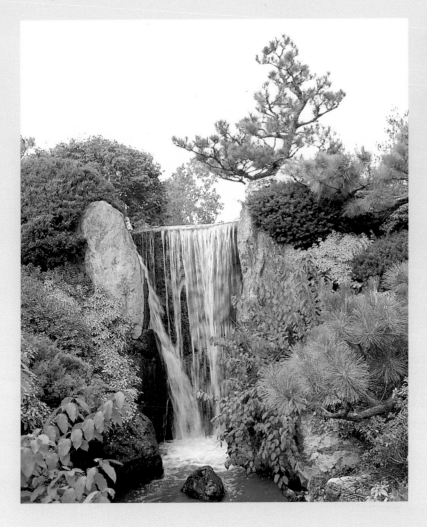

When you see the "carp stone"– a triangular rock just breaking the surface of the pool below the waterfall, you will remember a famous legend. It tells the story of a carp (*koi*) that struggled and fought its way upward through a pounding waterfall. When it reached the top, it was transformed into a fierce dragon.

The carp is a symbol of strength, power and determination for the people of Japan. Families fly carp banners from their homes on Children's Day (May 5) to honor the hope that their children will grow up to be strong and brave.

Koi of courage, will you try?

 Leaping, vaulting,

 Bounding up through pounding water–

Roaring dragon comes alive!

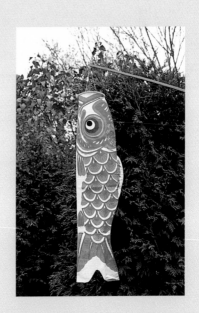

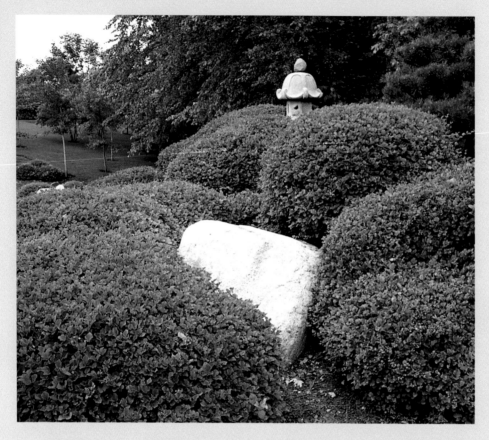

*O*karikomi, the pruning technique of closely clipping shrubs and bushes, became popular in Japanese gardens during the Edo period (1600–1868). It is used to create images of clouds, waves, islands or rocks.

Billowing mounds of green seen from across a pond or an area of raked gravel add depth and interest to the garden and often, in the long view, give the garden a layered, painting-like look.

The dwarf lilac bushes in this strolling garden are sculpted to look like clouds of mist hugging a mountaintop.

Cloudy mist, why drift so low?

Droplets, leaflets

Hugging hillsides,

Even shrouding lantern's glow.

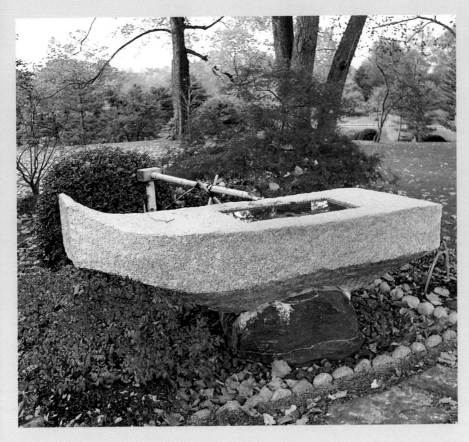

Funa-ishi, *what do you carry?*

Cargo of joy

Setting sail,

Coming and going as paradise ferry.

Leaving for paradise or just returning? Either way, this boat carries a cargo of happiness and serves as a symbol of joy in the garden.

Stories from long ago tell of mystical islands where people lived forever, trees blossomed with pearls and gemstones, and sacred mountains rose up from the sea. Giant turtles carried the islands of paradise on their backs.

Emperors sent ships to search for the islands, especially for the "fountain of youth." But each time a ship was about to touch their shores, a strong wind would come up and blow the islands just out of reach.

A thousand years ago, Japanese rulers tried with their gardens to create a paradise on earth–perhaps because their ships were never able to reach it on their own. The gardens had large lakes and ponds, and sometimes visitors rode in dragon-prowed boats, enjoying the sights and scents of flowers and trees.

A maple tree, planted in 1994 by the Emperor and Empress of Japan, grows behind this *funa-ishi* (boat stone) water basin.

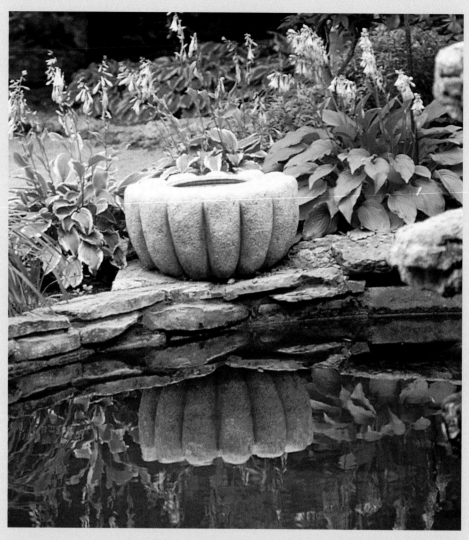

Someday you may be lucky enough to see chrysanthemums with a light dusting of snow on their leaves and blossoms. Chrysanthemums (*kiku*) are usually the last plant to bloom in autumn, so they signal winter's approach.

For more than 2,000 years, people in Japan have grown chrysanthemums. The term "Chrysanthemum Throne" refers to the royal family of Japan. Since 797, the imperial crest has featured a chrysanthemum. A sixteen-petal chrysanthemum is the official symbol of the Japanese Emperor.

Carved in stone and used as a water basin, this chrysanthemum will be beautiful throughout every season.

Chrysanthemum, are you filling to the brim?

Crown of petals

Catching raindrops,

Double bloom on water's rim.

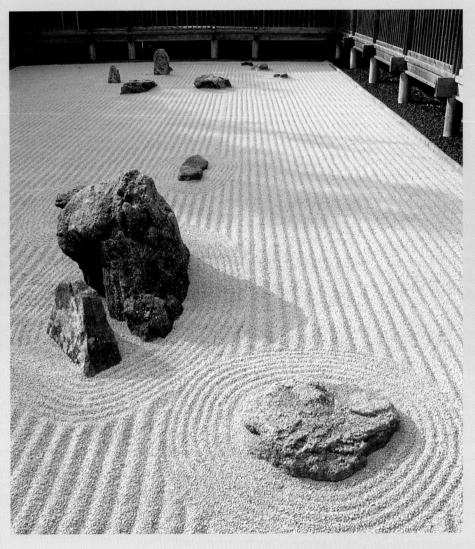

Do you see the islands? Do you hear the waves lapping at their shores? Without a single drop of water, the garden leads you to see and hear the ocean.

A dry landscape garden (*kare sansui*) may have an area of raked sand, an arrangement of rocks resembling a waterfall, or a channel of pebbles to indicate a stream. The garden only suggests water. Your imagination sees and hears it.

A dry garden is also called a Zen garden, named after a branch of Buddhism that arrived in Japan 800 years ago. Zen Buddhism emphasizes meditation and simple living in harmony with nature as ways to find inner peace.

Rather than entering or walking through a Zen garden, a visitor usually views it from a bench or pavilion. Sitting quietly, listening to the rhythm of your own breathing, observing the stillness of sand and stone, and thinking of the beauty of the garden, you may feel a moment of peace.

Sandy sea, how deep, how wide?

Islands floating,

Ripples lapping,

Fathom thoughts instead of tides.

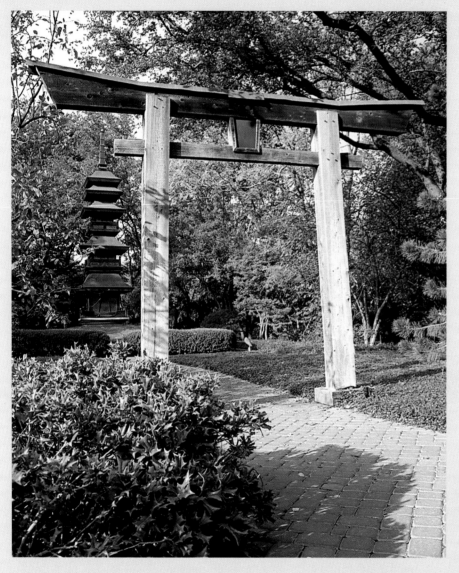

You may see a *torii* or a Shinto "gateway to heaven" standing on a hill or even in a pond near the shore. It grandly announces that a shrine lies just ahead.

Shintoism, the indigenous religion of Japan, honors nature and ancestors. *Kami* or sacred spirits are said to live in natural objects such as mountains, wind, waterfalls, trees and ponds. Some rocks are particularly revered and may be wrapped with straw ropes as a sign of worshipful respect.

Because the first gardens in Japan were special places set aside to invite spirits to visit earth, religious features are commonly found in Japanese gardens. Yet, while honoring the importance of religion in the development of garden design, most Japanese gardens today invite a more secular appreciation for their idealized expression of beauty, harmony and serenity.

Stately torii, why so tall?

Sign of shrines

Reaching skyward,

Heaven's gate that welcomes all.

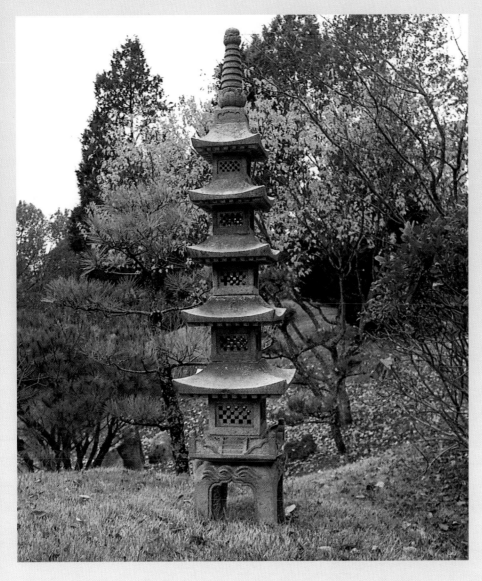

A stupa or pagoda-like stone tower serves as a memorial to Buddha, honoring his life and teachings. Pagodas are employed to save and protect family relics or ancient, special mementos.

The tiers of pagodas and stone towers always add up to an odd number. A small three-tiered *stupa* may represent earth, heaven and humans. A five-tiered *stupa* recalls the five natural elements of the universe—earth, water, fire, wind and metal. Nine rings extend from the tiers, representing the nine heavens of Buddhism. A lotus, the symbol for Buddha and enlightenment, usually crowns the top of a *stupa*.

Serving as a distinct focal point for garden viewing, a *stupa* is often placed on a hillside or just off a pathway nestled among evergreens. Either placement suggests the presence of a distant mountain temple.

Tower of stone, how great your reign!

Cosmic tiers

And rings of heaven,

Enlightenment and peace sustain.

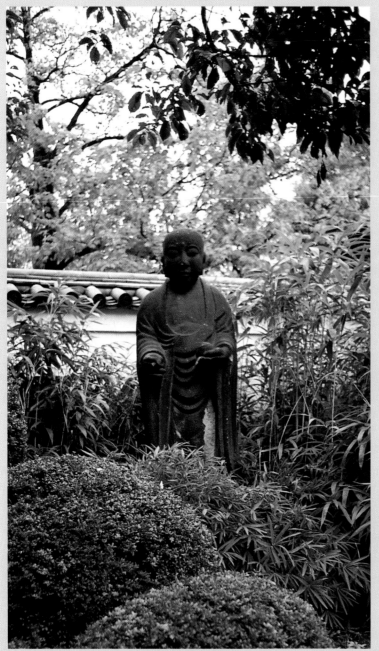

*B*uddha means "awakened one" and is a title given to Gautama Siddhartha, the man who founded Buddhism in India 2,500 years ago. He grew up in a wealthy family of warriors, but later came to believe that enlightenment or true peace should be the goal of everyone's life.

He believed that by casting aside all earthly cares and desires, he could find inner peace through meditation.

Buddhism is one of Japan's major religions. More than 300 million Buddhists in the world today honor Buddha's life and teachings. They celebrate Buddha's birthday (April 8) as their religion's most important holiday.

You may see statues and carvings of Buddha and other gods from Buddhism displayed in Japanese gardens. Here Jizo, the Buddhist god who protects young children, stands amid a grove of dwarf bamboo.

Quiet Buddha, who are you?

Peaceful spirit

Thinking, teaching:

Look inside to find what's true.

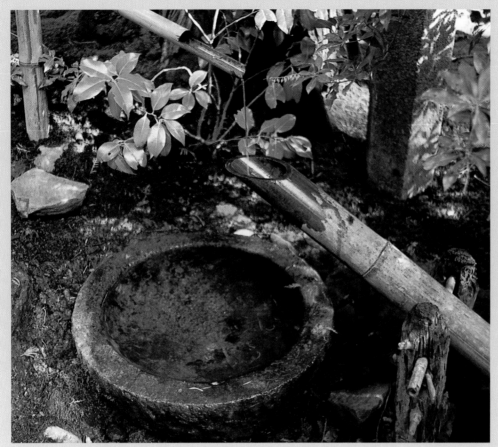

Japanese gardens invite you to listen as well as look.

Used by farmers many years ago, a deer chaser (*shishi odoshi*) with its sharp clacking sound frightened hungry deer away from vegetable gardens. It is a popular "sound ornament" in Japanese gardens today.

When filled with water, the lower bamboo pipe tips downward, empties and quickly pivots back up. The bottom end of the pipe strikes a rock, creating a loud "clack" that echoes through the garden.

Shishi odoshi, *is that you I hear?*

Water trills. Bamboo fills, spills,

Then swings back—CLACK!

Scares away the deer!

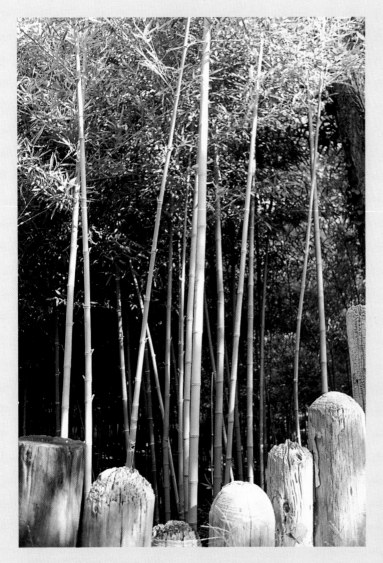

In a breeze, you may hear a bamboo grove making soft rhythmic music. The leaves swish and rustle. The swaying culms (stems) gently click as they bump into one another—a living, growing rhythm band in the garden.

Even when it grows to be 100 feet tall, bamboo is still considered a member of the grass family. It is not a tree. It becomes woody only when it stops growing. Its sections from joint to joint remain hollow. Bamboo is strong, but lightweight and flexible.

The bamboo varieties most common to North America are medium-size, about ten to fifty feet, and small, under ten feet.

Even if a garden has no living bamboo, you are still likely to see crafted bamboo—fences, gates, pipes for a water basin, or bent split canes for edging a path.

Swaying bamboo, what's your sound?

Windy whisper,

Breezy chatter,

Motion music all around.

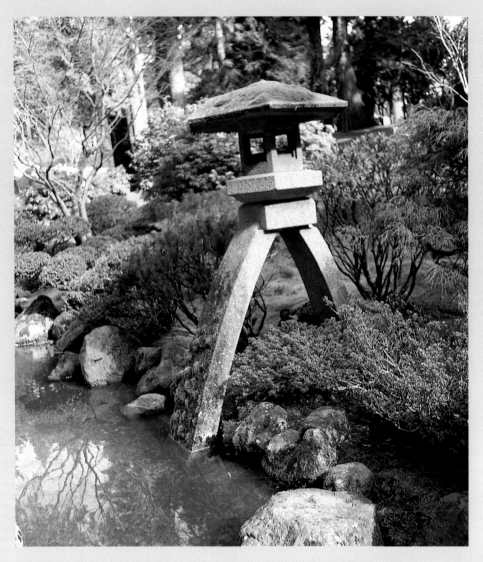

With its broad stance, the *kotoji* lantern resembles one of the tuning bridges on a *koto*, a traditional Japanese thirteen-stringed instrument. The *koto*, often compared to a harp or zither, is about six feet long and one foot wide. The musician tunes the strings of the *koto* by moving each of the thirteen bridges. Because of its likeness to these tuning bridges, the *kotoji* is called the "harp tuner" lantern.

You will always see a harp tuner lantern "playing a duet," with one foot on land and one in water. It symbolizes the harmonious composition created when elements of nature work together in the garden.

Kotoji *lantern, where do you stand?*

Lighting water.

Lighting earth.

Balancing on stream and land.

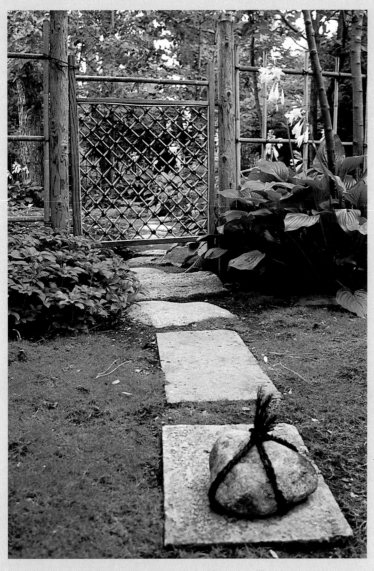

When you see a guardian stone (*sekimori-ishi*) on the path leading to the teahouse, you will know that the path is closed and the tea master is not at home.

A stone about the size of a softball and tied with a length of black-dyed cord serves as a guardian of the path. It is a polite way to say, "Keep out!"

Guardian stone before the entry

Gently warning:

"Please come no further. This path is closed."

Heed the silent sentry.

If you think Samurai were brave Japanese warriors who excelled in the martial arts, you're right. But they also loved their country's poetry, paintings, music and especially the tea ceremony.

The tea ceremony emphasizes peace and harmony. Every step of preparing and serving the special powdered green tea is done today just as it was first done 500 years ago.

The teahouse garden (*roji*: "dewy path") is a quiet place designed to help you relax and rest your mind. The stepping-stone path slows your pace. A bench invites you to sit and think quietly. A water basin offers you a place to rinse your hands and mouth. The beauty of the garden helps you enjoy the moment, forgetting about the worries of yesterday and tomorrow.

Even the door to the teahouse emphasizes peace. Not quite three feet high, it requires guests to enter on their knees, a humbling gesture. It also prevents a Samurai from entering the teahouse while wearing his sword!

Rustic teahouse, who's your guest?

Samurai in search of peace

Journeys over dewy path,

Placing silver sword at rest.

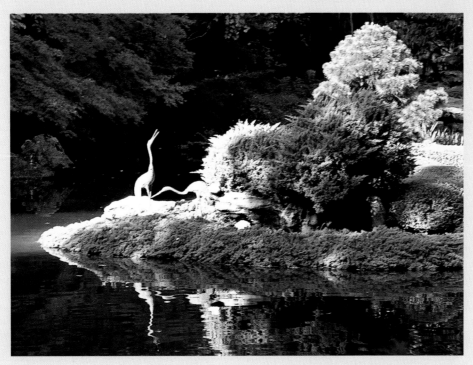

Cranes play a prominent role in the cultural traditions of Japan. The red-crowned crane is Japan's national bird. Its image is pictured on the nation's currency and, as an endangered species, it is now protected. It is said to have one of the most beautiful dances in the bird world.

In ancient Buddhist stories, cranes were sacred birds who carried the "immortals" on their backs, while flying around the islands of paradise. Cranes were believed to live 1,000 years and to bring good fortune and happiness.

Because they mate for life, cranes bring a promise of faithfulness to a marriage, in addition to their blessings of long life and happiness. Their image is often embroidered on a bride's kimono.

In a Japanese garden, cranes may be represented realistically as paired sculptures or abstractly as a "crane hill" or "crane island." In the latter, usually a tall upright stone is featured in a stone-and-plant composition.

Faithful cranes, what brings you here?

Graceful flight,

A dance on wind,

Foretelling many happy years.

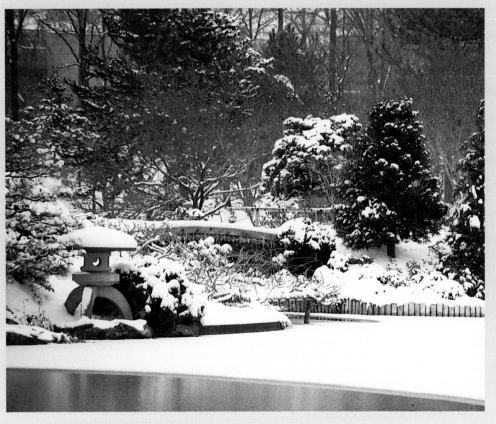

With its broad *kasa* ("hat"), a *yukimi* lantern is perfectly shaped to catch a soft mound of snow. That is when it most resembles a farmer's woven rush hat. The Japanese word for snow is *sekka*, which literally means "winter flower."

A *yukimi* lantern or "snow- viewing" lantern is short and stout and always stands next to water—real or imaginary. Its firebox sits low. When you look across the pond, its light will make a beautiful, flickering reflection in the water.

If you visit a Japanese garden in summer, will you be able to imagine the *yukimi* lantern with its hat covered in snow?

Yukimi *lantern, what stuff is that?*

 Softly, softly

 Snow alighting,

Winter flowers on your hat.

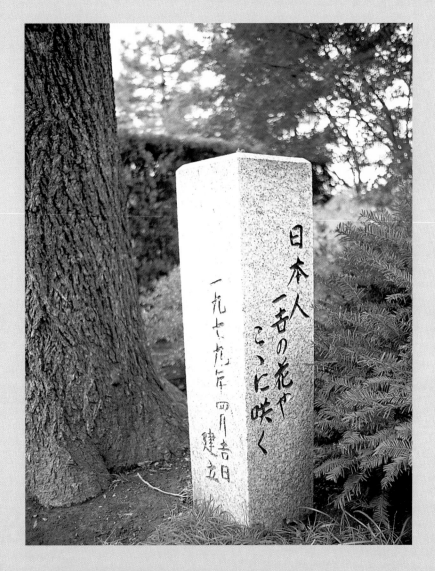

日本人
一舌の花や
ここに咲く

一九七九年 四月吉日
建立

Haiku stone, what do you say?

Poet's heart

Sees nature's soul,

And then the moment slips away.

Japanese poets have often written poems inspired by garden scenes and experiences. In many Japanese gardens, you may find a stela inscribed with a special type of poem, a *haiku*.

Haiku, a 400-year-old form of Japanese poetry, tries to capture brief moments and feelings in few words. *Haiku* are short, non-rhyming poems. Written in three lines, they often use a 5-7-5 syllable structure.

Traditional *haiku* focus on nature and often use "seasonal code words" (*kigo*). For example, a frog refers to summer, a bright moon indicates autumn, fallen leaves suggest winter, and flowers spring. There are many special words associated with each season.

The *haiku* engraved on this stela was written by the late Koichi Kawana, designer of the Japanese garden in St. Louis, Missouri. Reading the *kanji* (characters) in columns from right to left, it translates: "Japanese people/first immigrant flowers/blossom here." The dedication date (1979 April) is identified on the left face of the pillar.

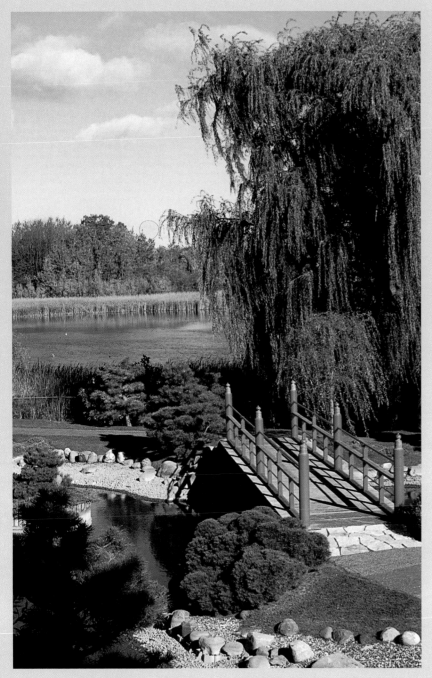

Shakkei means "borrowed scenery." A garden designer carefully assesses what lies beyond the boundaries of a proposed Japanese garden. If unsightly buildings or highways are nearby, then a fence or wall is often erected to screen their view from within the garden. But if mountains, hills, lakes, woodlands or even interesting features such as a city skyline or temple shrine border the garden, they are "borrowed" or intentionally incorporated into the garden's viewpoints and perspectives.

Here it is difficult to tell where the garden ends and the wetlands preserve begins. The natural beauty of the marsh and distant trees increases the perceived depth of the garden and generously extends its panoramic vista.

Shakkei, *where are you found?*

Garden borders

Melting, merging,

Extend the beauty all around.

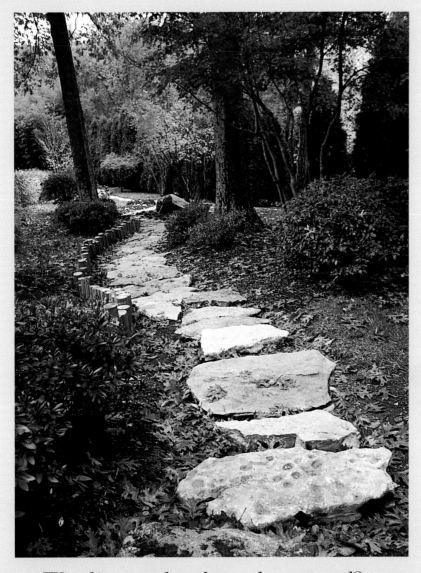

In a strolling garden, paths wind and curve only to disappear up ahead. Japanese gardens are deliberately designed to "hide and reveal" features along the path. It is a way of adding mystery to the garden. Your curiosity beckons you forward—"what's next?"

You may hear a waterfall from this point on the path, but you can't see it. It's one last surprise for you to discover, lying just up ahead ...

Winding path, where do you end?

Imagination's

Hide and seek—

One last surprise lies 'round the bend ...

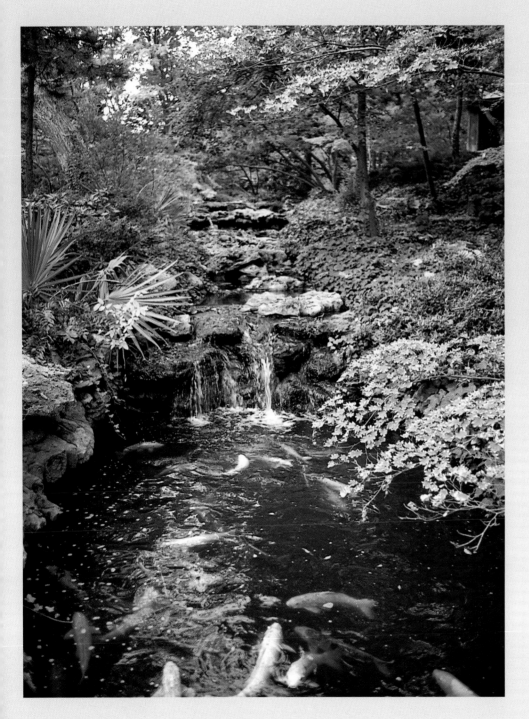

… and around the bend you find a waterfall with *koi* swimming below. On your next Japanese garden journey, perhaps a legend will come alive, and you will catch a glimpse of a roaring dragon, too.

Japanese Gardens in the United States and Canada

*T*he best way to learn more about Japanese gardens is to visit them. More than 150 public Japanese gardens have been created in North America. They are found in parks and botanical gardens, on university campuses and corporate grounds, near museums and libraries. Many are free; some require an admission fee. Before you visit, be sure to check a guide book or local tourist information office to determine hours of operation and fees.

Visiting a garden can lead you to other explorations of Japanese culture as well. Many of the gardens listed below host festivals featuring a sampling of traditional arts and crafts, such as tea ceremony demonstrations, *taiko*-drumming, dance, music, *origami* (paper-folding), calligraphy, *ikebana* (flower-arranging), *bonsai* displays and Japanese cuisine. The festivals often correspond to customary Japanese observances, such as chrysanthemum-viewing, moon-viewing or cherry blossom-viewing.

United States Gardens

Alabama

Birmingham
Birmingham Botanical Gardens

Theodore
Bellingrath Gardens

Tuscaloosa
Gulf States Paper Corporation

California

Bel-Air
Hannah Carter Japanese Garden, UCLA

Berkeley
University of California at Berkeley Botanical Garden

Corona del Mar
Sherman Library and Gardens

Hayward
Japanese Gardens, Hayward Area Parks and Recreation

La Cañada Flintridge
Descanso Gardens

Lodi
Micke Grove Park and Zoo

Long Beach
Earl Burns Miller Japanese Garden

Los Angeles
New Otani Hotel

Oakland
Lakeside Park Garden Center

Pacific Palisades
Self-Realization Fellowship Lake Shrine

Santa Barbara
Ganna Walska Lotusland

San Diego
Murata Pearl Garden, Sea World

Japanese Friendship Garden

San Francisco
Japan Center

Japanese Tea Garden, Golden Gate Park

Strybing Arboretum and Botanic Gardens

San Jose
Japanese Friendship Garden, Kelley Park

Buddhist Temple

San Marino
Huntington Library and
Botanical Gardens

San Mateo
Japanese Garden and
Arboretum, Central Park

Saratoga
Hakone Gardens

St. Helena
Newton Vineyard
Japanese Garden

Van Nuys
Japanese Garden, Tillman
Water Reclamation Plant

Whittier
Rose Hills Memorial Park

Colorado

Denver
Denver Botanic Gardens

District of Columbia

Hillwood Museum

Ippakutei, Embassy of
Japan

U.S. National Arboretum

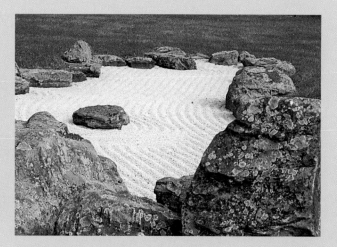

Florida

Delray Beach
The Morikami Museum
and Japanese Gardens

Fort Pierce
Heathcote Botanical
Gardens

Miami
Ichimura Miami Japan
Garden, Watson Island

Palm Beach
Society of the Four Arts

Georgia

Atlanta
Atlanta Botanical
Garden

Carter Presidential
Center and Museum of
the Jimmy Carter Library

Fort Valley
Massee Lane Gardens

Hawaii

Hilo (Hawaii)
Liliuokalani Gardens Park

Honolulu (Oahu)
The Contemporary
Museum

Honolulu City Hall

National Memorial
Cemetery of the Pacific

East-West Center,
University of Hawaii

Soto Zen Buddhist Temple

Kaneohe (Oahu)
Byodo-in Temple

Kalaheo (Kauai)
Kukuiolono Park

Olu Pua Gardens and
Plantation

Wailuku (Maui)
Heritage Gardens,
Kepaniwai Park

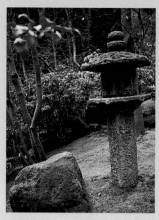

Illinois

Belle Rive
Enchanted Crest

Carbondale
Japanese Garden,
Southern Illinois
University

Chicago
Osaka Garden,
Jackson Park

Westin-Nikko Hotel

Decatur
Scovill Gardens Park

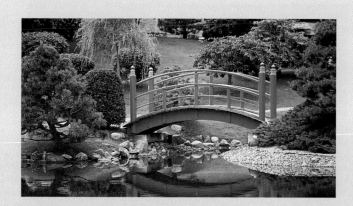

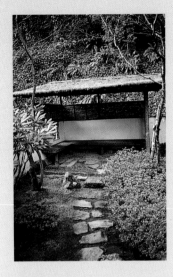

Iowa

Dubuque
Dubuque Arboretum and
Botanical Gardens

Muscatine
Muscatine Art Center

Louisiana

New Iberia
Live Oak Gardens,
Jefferson Island

Maine

Northeast Harbor
Asticou Azalea Gardens,
Mount Desert Island

Maryland

Jacksonville
Ladew Topiary Gardens
and Manor House

Wheaton
Brookside Gardens

Massachusetts

Boston
Boston Museum of
Fine Arts

Edgartown
Mytoi, Chappaquiddick
Island

Northampton
Smith College Botanic
Garden

Salem
Peabody Essex Museum

Westfield
Stanley Park

Michigan

Bloomfield Hills
Cranbrook House and
Gardens

Midland
Dow Gardens

Niles
Fernwood Botanic Garden
and Nature Center

Saginaw
Tokushima Saginaw
Friendship Garden

Minnesota

Bloomington
Normandale Community
College

Chanhassen
Seisui-Tei, Minnesota
Landscape Arboretum,
University of Minnesota

Northfield
Carleton College

Saint Paul
Como Ordway Memorial
Japanese Garden

Geneva
Fabyan Villa Japanese
Garden

Glencoe
Sansho-en, Chicago
Botanic Garden

Rockford
Anderson Gardens

Urbana-Champaign
Japan House
(future garden)

Indiana

Mishawaka
Shiojiri Niwa,
Merrifield Park

Mississippi

Jackson
Josh Halbert Garden

Mynelle Gardens

Missouri

Centralia
Chance Gardens

St. Louis
Seiwa-en, Missouri
Botanical Garden

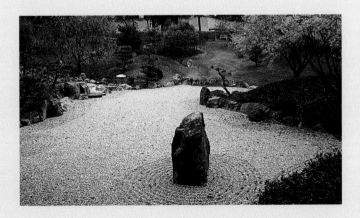

New Hampshire

North Hampton
Fuller Gardens

New Jersey

Lakewood
Georgian Court College

Somerville
Duke Gardens

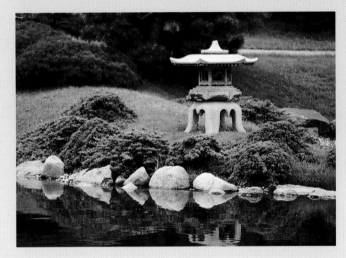

New York

Brooklyn
Brooklyn Botanic Garden

Buffalo
Delaware Park

Canandaigua
Sonnenberg Gardens

Millbrook
Innisfree Garden

Mill Neck
The John P. Humes
Japanese Stroll Garden

North Salem
Hammond Museum Stroll
Gardens

Old Westbury
Old Westbury Gardens

North Carolina

Clyde
Campus Arboretum,
Clyde College

Ohio

Akron
Stan Hywet Hall and
Gardens

Cleveland
Cleveland Botanical
Garden

Rockefeller Park

Columbus
Franklin Park
Conservatory and
Botanical Garden

Newark
Dawes Arboretum

Oberlin
Oberlin College

Oregon

Coos Bay/Charleston
Shore Acres State Park
and Botanical Gardens

Gresham
Multnomah County
Library

Newberg
Garden of Friendship,
Chehalem Valley Middle
School

Portland
Japanese Gardens,
Washington Park

Pennsylvania

Bethlehem
Serenity Garden, Sakon
Plaza, City Center
Complex

Haverford
Haverford College

Hershey
Hershey Gardens

Malvern
Swiss Pines

Philadelphia
Japanese House and
Garden, Fairmount Park

Morris Arboretum,
University of Pennsylvania

Pittsburgh
Phipps Conservatory

Rhode Island

Providence
Roger Williams Park

South Carolina

Greenville
The Japanese Garden,
Furman University

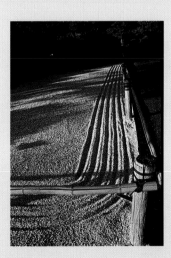

41

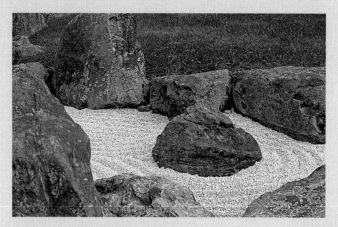

Tennessee

Memphis
Seijaku-en, Memphis Botanic Garden

Nashville
Cheekwood Tennessee Botanical Garden and Museum of Art

Texas

Austin
Zilker Botanical Garden

Fort Worth
Fort Worth Japanese Garden, Fort Worth Botanic Garden

Houston
Japanese Garden, Hermann Park

San Antonio
San Antonio Botanical Center

Utah

Salt Lake City
International Peace Gardens

Virginia

Norfolk
Norfolk Botanical Gardens

Richmond
Maymount

Washington

Bainbridge Island
Bloedel Reserve

Bellevue
Yao Park, Bellevue Botanical Garden

Ellensburg
Central Washington University

Olympia
Yashiro Japanese Garden

Seattle
The Japanese Garden, Washington Park Arboretum

Kubota Gardens

Spokane
The Nishinomiya Garden, Manito Park

Tacoma
Point Defiance Park

Wisconsin

Janesville
Rotary Gardens

Canadian Gardens

Alberta

Devon
Kurimoto Japanese Garden, University of Alberta

Lethbridge
Nikka Yuko Japanese Garden, Henderson Park

British Columbia

New Westminster
Japanese Friendship Garden

Vancouver
Nitobe Memorial Garden, UBC

Pacific National Exhibition, Hastings Park

Vernon
Japanese Garden, Polson Park

Victoria
The Butchart Gardens, Brentwood Bay

Ontario

Guelph
University of Guelph

Quebec

Montreal
Montreal Botanical Garden

The Internet

For more information, search "Japanese Gardens" on the World Wide Web. A few of the gardens listed above have websites with photographs, calendars of events and hours of operation. For addresses and additional Japanese garden information, try the Japanese Garden Database at the following WWW address: http://pobox.upenn.edu/~cheetham/jgarden/index.html

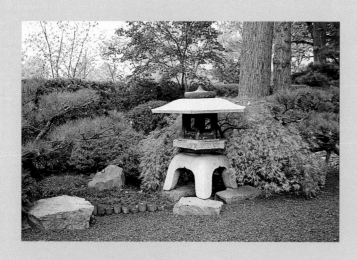

Related Readings

Addiss, Stephen. *A Haiku Garden: The Four Seasons in Poems and Prints.*
New York: Weatherhill, 1996

Cave, Philip. *Creating Japanese Gardens.* Rutland, VT: Charles E. Tuttle, 1993

Davidson, A.K. *The Art of Zen Gardens: A Guide to Their Creation and Enjoyment.*
New York: Putnam, 1983

Engel, David H. *A Thousand Mountains, a Million Hills: Creating the Rock
Work of Japanese Gardens.* Tokyo: Shufunotomo Co., Ltd., 1995

Hamilton, Bruce Taylor. *Human Nature: The Japanese Garden of Portland,
Oregon.* Portland: The Japanese Garden Society of Oregon, 1996

Keane, Marc P. *Japanese Garden Design.* Rutland, VT: Charles E. Tuttle,
1996

Oster, Maggie. *Reflections of the Spirit: Japanese Gardens in America.*
New York: Dutton, 1993

Seike, Kiyoshi; Kudo, Masanobu, and Engel, David H.
A Japanese Touch for Your Garden. Tokyo: Kodansha International, 1992

Yamashita, Michael S. and Bibb, Elizabeth. *In the Japanese Garden.*
Washington, D.C.: Starwood Publications, 1991

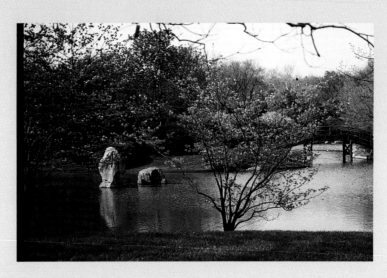

Garden Locations Photographed by the Author and Reproduced by Permission of the Gardens Listed

Anderson Gardens, Rockford, IL: page 27 (bottom)

Cheekwood Tennessee Botanical Garden and Museum of Art, Nashville, TN: frontispiece, pages 25, 36, 40 (bottom)

Como Ordway Memorial Japanese Garden, St. Paul, MN: colophon page (top);pages 10, 11, 17, 20, 30, 31

Dawes Arboretum, Newark, OH: pages 39 (top), 42 (top)

Fort Worth Botanic Garden, Fort Worth, TX: pages 14, 23, 24, 28, 32, 37

Japanese Gardens, Portland, OR: colophon page (bottom);pages 7, 9, 12, 27 (top), 29, 38 (top), 39 (center), 40 (left), 42 (right),43 (top)

The Japanese House and Garden, The Fairmount Park Commission of the City of Philadelphia, PA: front cover; pages 6 (top), 26, 40 (top right)

Memphis Botanic Garden, Memphis, TN: pages 5 (top), 8, 13, 15

Minnesota Landscape Arboretum, University of Minnesota, Chanhassen, MN: page 16, back cover (bottom)

Missouri Botanical Garden, St. Louis, MO: back cover (top), title page, pages 5 (bottom), 6 (bottom), 18, 19 (left), 21, 33, 34, 41(bottom),43 (top), 44

Morris Arboretum, Philadelphia, PA: pages 38 (bottom), 41 (top right)

Normandale Community College, Bloomington, MN: pages 35, 39 (bottom), 41 (left), 43 (bottom)

Rotary Gardens, Janesville, WI: page 22